Above the Waves' Calligraphy

SALMON PUBLISHING LIMITED

receives financial assistance from the

Arts Council/An Chomhairle Ealaíon.

•

Patricia Burke Brogan

Above the Waves' Calligraphy
A Collection of Poems and Etchings

SALMON POETRY

Published in 1994 by
Salmon Publishing Ltd,
Upper Fairhill, Galway
A division of Poolbeg Enterprises Ltd

© Patricia Burke Brogan 1994

The moral right of the author has been asserted.

A catalogue record for this book is available from the British Library.

ISBN 1 897648 23 5

Cover etching by Patricia Burke Brogan
Interior etchings also by Patricia Burke Brogan
Cover design by Poolbeg Group Services Ltd
Set by Poolbeg Group Services Ltd in Palatino 11/15
Printed by Colour Books, Baldoyle Industrial Estate, Dublin 13

To the memory of my parents
Mary and Joseph Phelim Burke

Acknowledgements

The author is grateful to the editors of the following publications in which some of these poems first appeared:

The Salmon Magazine, *Writing in the West* (Connacht Tribune), *Women's Work* (Wexford), *Living Lanscape Anthology* (Kerry), *The Humours of Galway Anthology* and *Seneca Review* (USA).

Acknowledgements are due to Galway Writers' Workshop, Listowel Writers' Week, Cuirt International Writers' Workshop, Galway Arts' Centre, National Writers' Workshop UCG, The Tyrone Guthrie Centre, Galway Bay FM and RTE Television.

The author is also grateful to Dr. Laura Vecchi Ford, Grafica 11 (Ireland) UCG, Listowel International Biennale, Kenny's Bookshops and Art Galleries and to the Jury of Mini Print Internacional De Cadaques Barcelona, who chose some of these etchings for reproduction.

Contents

Haunted Space

Sanctuaries

Triangle of Sail

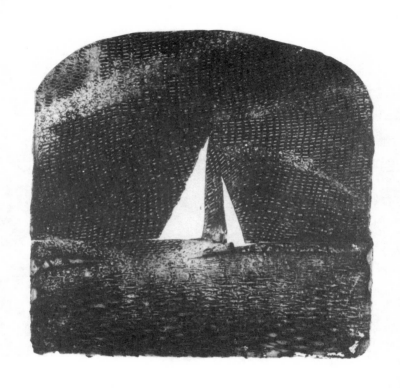

Pucán

Triangle of Sail

I
Triangle of sail,
white veil of a nun,
tilts and turns
in cloistered waves.
Triangle of sail
glows.
Seaweed scatters,
twists and tangles,
rosary beads abandoned
by a shrouded nun.
Plainchant of ocean,
elipse of bay,
Black Head bows
to Ballinagall.

II
Triangle of sail.
A silvered fin
tilts to the sun,
glows sapphire and topaz,
when I sing Oratorio
my fins opaline
above the waves' calligraphy.

III
Before I shed
each sequined skin
and slowly
raise my skull
to the sun,
before my lungs
grow to first breath
and I stand upright
on clay and sand.
Before thought,
throat, tongue, lips
form my first word.
Before, eyes open,
I see the moon
through a blizzard of stars
and dawn transfigure
the indigo night.

A silvered fin
from another time,
another life
glows.
A silvered fin,
triangle of sail,
triangle of sail.

Magnificat

The Angelus rings.
I fold my serge habit.
For the last time
I remove the starched half-circle
from my heart.

Not back here again!
No. No. No!
Do I hear the scrape
of scissors cold on my skull,
as that dark-voiced Superior
shears my hair?
Waxed corridors. Silent shapes.
Incense-drenched Magnificat.
Again. Again.

'No vocation, Sister?
You a black novice! No vocation.
You are sure? Sure. Sure.
You mustn't tell. You must wait.
Permission from Rome.
I put you under Obedience.
A Mortal Sin if you tell'

No Vocation? No Vocation!
Not in here – again!
Must I untie coif and veil,

fold black serge habit,
remove that ring engraved
with Christ Crucified?
Again. Again.

Blessed by the Bishop
in magenta robes?
 No! No!
 Black robes.

A black dream.
 Rattle of rosary beads
 in a black cloister.
 'You mustn't tell.
 You must wait!'

The Angelus rings.
I fold my black dream
and leave it
in the convent parlour.

Cell

An ancient door opens.
Stony cloisters.
Dark corridors.
Incense, silence.
A cell with white-washed walls.
Stripped of worldly bronzes,
I put on black habit, white veil.
Soprano-voiced Magnificat
drifts from chapel.
In the refectory
black shapes masticate,
as I read from St. Paul.
'If I have all the eloquence
of men or of angels
and have not Charity,
I am but a booming gong,
a clashing cymbal.'

Under double-lock.
Caged deep
beneath waxed floor-boards,
penitent mothers
in a laundry underworld
bleach away our sins.

Groaning womb-cauldrons
strangle eye-beats, heartbeats.
Huge irons flatten the acid-white sheets
of my Credo
in a black-barred cell.

Etched Torso

'To be an artist is to fail, as no other dare fail.' Beckett

In the acid bath
a copper plate
grows dull in turquoise bubbles.
Fumes sway up
from skull thorn-pierced,
shattered shoulder,
torn ribspace.

Acid washed away
in clear water,
she places the etched plate
on a wire-meshed stove.

Gauze-masked, she watches
incense of melting resin rise
above mounds of ink
on double-imaged glass shelves.
Orient Blue, terracotta,
crimson alizarin,
warm sepia, cerulean.
Incense soars above rows
of glimmering etched plates,
above tins with strange messages,
Laurence of Bleeding Heart Yard.
Charbonnel, Quai Montebello, Paris.
Urbino, Via Sasso, Italia.

Unprotected by opaque bitumen
in the acid-bath of resin bubbles,
the etched torso darkens.
Dies.

Grappling with a vision,
she takes a burin and cuts
thin ribbons from tawny metal flesh.

From bundles of soft-textured paper
Fabriano, Arches, Saunders,
she chooses an ivory sheet.

The printing-press shrieks
as, pushed between huge cylinder
and bed of the press,
forced between etched lines
and open-bite spaces,
the soft damp paper
takes an inked-up relief.

Disappointed,
she pins the failed image
on a drying line.

Leaving the workshop's
dull glow of copper, neutral of zinc,
she walks out into rain.

A gauzed sky reflects on tarmac.
Between brimming sycamores,
arrows and double yellow lines
are tattoos on soft skin of earth.

As she walks through water,
through double-imaged clouds,
she finds a Coke tin
distorted by heavy wheels.

A bruised tin man
hangs between earth and sky.

Cloisters of Alghero

From dark caves above Granada,
where entranced Moors sleep,
Paco Pena calls gipsy voices
to the cloisters of Alghero.

Beneath the Tower of Maddalena
oleanders open crimson ears.
Sand-lilies lift silver trumpets.
In the ancient city of Alghero
bougainvilleae stains ochre walls.

Chevrons, circles, embossed triangles,
terracotta calligraphy of strings,
olive, jasmine, lemon elipses,
blood-dried earth of Andalucia
in the cloisters of San Francesco.

Ice and flame, laments and love songs,
dark magic on curving strings,
glow of pink on gold Alhambra
under snows of Sierra Nevada.

Along Via Roma and Via Columbano
from Torre Saint Joan,
above the crickets' soft percussion,
under slanting ilex trees
through the island of Sardegna
flows a red-gold river of flamenco.

They come from that scarred Mountain,
Mountain of Pain, Mountain of Fear.
Ancient people quicken from
shadowed doorways of Nuraghe.

The sleeping youth of Aesculapius wakes
to hear scalloped music.

Phoenicians and Genoese to the Piazza Civica.
Zig-zag Romans on white horses.
After them Catalans and Aragonese.
Under the Bell-Tower thousands gather,
the Bell-Tower of Sancta Maria.

Chevrons, circles, embossed triangles,
terracotta calligraphy of strings,
olive, jasmine, lemon elipses,
blood-dried earth of Andalucia
in the cloisters of Alghero.

Good Friday, Co. Monaghan 1989

"Where do you come from?
Where are you going?
Where? Where? Why?"
Soldiers, heavy with guns,
circle a checkpoint.

Dry throat silent.
Snow-bullets crimsoned,
carmine of rhododendron
stains the green.

Dark voices barter
for a seamless vest
here, where flesh explodes
and that bruised head
looms between the trees.

Snow deepens
its white winding sheet
on Rockcorry, Newbliss
and Annaghmakerrig.

The sun splinters.
Forsaken,
that pierced heart dies.
Day is Night.

Letters To Vermeer

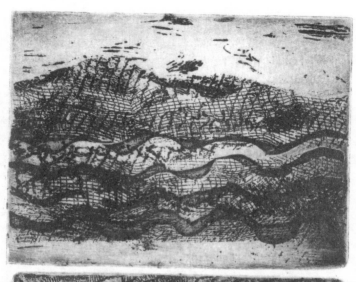

Aloha

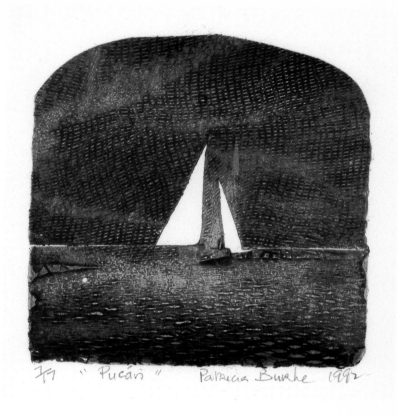

Night Beach

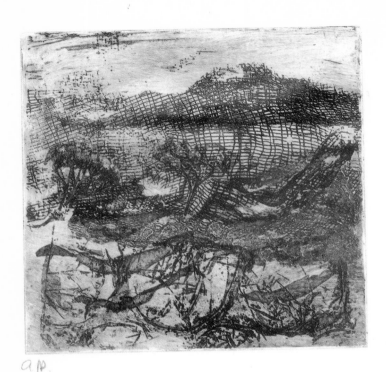

a p.

Letters to Verneer

Letters to Vermeer

Galway City,
September 4, 1993

Dearest Jan,
Thank you for writing by return.
Good news at last.
Your Letter-Painting was found in Antwerp.
Yes, that stained-glass window
still highlights contours of your lady writer.
Rubies and burgundies glow on your table-cover.
Has the woman, who watches from chiaroscuro,
scrubbed those black and white tiles this morning?
Women don't scrub nowadays, Johannes!

In all your letters you promise to come soon!
You must visit us in this many-textured place.
You must paint our Holy Mountain
before concrete bunkers disguise its magic!
All the blues you love are here, Jan.
Cobalt, indigo, ultramarine, cerulean.
And in April you'll find Gentians!
No, you won't have to grind colours.
Paints come in tubes now.

So please, please come soon.

Love, Patricia

II
Galway City,
September 7, 1993

Dearest Jan,
Please hurry!
This week we dig up skeletons
of outcast laundry women
and sell their graveyards to builder-developers.

Will we steal your paintings of the Holy Mountain?
In a rush to post,

Love, Patricia

III
Galway City,
September 12, 1993

Dearest Jan,
Thank you for this drawing of Delft.
I shall treasure it forever.
I'm sorry you were delayed again.
Wish you were here, for to-day
we sail from Rinville to Ballyvaughan.
Turner, your paint-brother, wrapped himself in mast sheets,
while storm-battered, he painted sailing ships
in the English Channel.
But do I glimpse your shadow, your stillness, beside

our main sail, as you sketch pucans and wave-patterns?
No. – I'm only dreaming, Jan!
Beyond Cockle Rock, the sea swells and we move, tiller steady,
towards the Burren, where huge limestone dolphins
reflect in wave-calligraphy.
Every Spring our Burren breaks into flower-miracles
to honour St Colman, the monks of Corcomroe,
the dead of Poulnabrone and Gleninsheen.
Across the bay the Twelve Pins rise and crumple
as we point first towards Black Head.
Inis Meáin to starboard.
Napolean's Martello Tower and Bell Harbour portside.
Spinnaker folded,
we tack and coast between lurking rocks
through this oyster-packed channel.
A gleoteog's burgundy sails
blaze under folded limestone.
Alongside Ballyvaughan pier
we put out fenders, fasten ropes,
as Clare music echoes through Aillwee,
where Sidney Nolan paints
to textured rhythms of his ancestors.

I look forward
to the silver light
of your brushstrokes,
to seeing you very very soon.

Love, Patricia

P.S. Bring sweaters and rain-wear.

Mid-Summer Chat

'It's all daylight now,' moans old Bartley
in a womb-dark pub on the beach.
'Isn't that what you want?'
mutters gold-earringed John-Joe.

'Long nights. Away from that sea!'
Bartley grunts through pipe-smoke.

'A sniff!' John-Joe retorts.
'It's a straw you need.
A straw for cocaine.'

'Old times, old dreams!
Dancing with
my Rosaleen
at a crossroads
near Doolin.'

'History!' John-Joe snorts,
looking through windowed sunshine,
as waves pleat, roll and shatter.

Distorted Journey

We cannot swim.
My sisters, my brothers,
we cannot swim in Loch a tSaile.
Cormorants, herons,
we walk on bronze-ruffled ice.
Mirrored in frozen glass,
we move in feathered
choreography
across crystalized space.

Above us
the sun, snow-coifed,
bends to explore
shattered viridian cloisters,
to pin frosted rainbows
on the cold skin
of our sea-lake.

Above you
my sisters, my brothers,
the same sun
gauzed in orient blue,
is hidden
by metal wings.

We weep for you
 our sisters, our brothers
 captured in that oil-cage.
 We weep
 for your burning eyes,
 throats scream-swollen,
 your charred wings
 heavy on an
 oil-batiked sea.
We see you move,
 amnesiacs, in black ooze.
Smoke fumes,
 huge dark anemones
 in a bruised sky,
 distort your journey.
Our sisters, our brothers,
 we watch you float,
 towards the flaming arms
 of that oily monster.
 Towards that
 poison kiss
 of man on the
 amber lips
 of Khafji Sea.

Loch a tSaile

　　　　　　To-night
Loch a tSaile,

　　　　　　face jaundiced by a bitter moon,
groans in the storm ------

　　　　　　"I am old and dying.
My tongue twists swollen
　　　　　　through that gapped railway bridge.
My hair,
　　　　　　a tangle of ochre seaweeds,
distorts
　　　　　　cadenced swans.
My deep dark belly smells." -----

　　　　　　To-night,
the sun shines
　　　　　　on the other side of the world.

Diary

We didn't see the star,
the star that blazed in the heart
of the fine-boned man
we met in Amsterdam.
Unknown to us
skeletons smouldered
in the shadows of his topaz eyes.
The cross of iron
twisted and crooked
through the skull of the man,
who bought us Old Genever
in the American Bar
of Hotel Krasnapolski.
'I am seventy-two', he said
I drink Young Genever.'

Mirroring his daughter's truth,
Otto Frank told us quietly,
'I am against discrimination of every kind.'

Three-Year-Old Poet

Lonely for the Shannon,
lonely for the ocean,
she sits on a cold doorstep.
'No sand here. No fishes, no boats.
No wave-colours. No wave-music.
Could I walk to Kildysert, Brendan?'

'You're too small!
But I'll make you a poem.

The crow is on the aerial
away, away, away.
The crow is on the aerial
away, away, away.'
her brother chants.

She sits on a cold doorstep
wishing she could fly
like a crow.

This Winter

This winter
we cannot see
the six-twenty train to Dublin
thread golden beads
through capillaried sycamores,
but we hear its iron pizzicato.

Concrete buildings
new beneath our tricolour
scar the night.
This winter
and all future winters,
unseen from our dinner table,
the six-twenty,
its orange-tipped finger
punctuating the moon,
will stitch
cinnabar of Atlantic
to the fossil-fields of Clare.

Make Visible the Tree

This is the Place of Betrayal.

Roll back the stones
behind madonna blue walls.
Make visible the tree.

Above percussion of engines
from gloom of catacombs,
through a glaze of prayer,
scumble of chanting,
make visible the tree,
its branches ragged
with washed-out linens
of a bleached shroud.

In this shattered landscape,
sharpened tongues
of sulphur-yellow bulldozers
slice through wombs
of blood-soaked generations.

This is the place,
where Veronica,
forsaken,
stares and stares
at a blank towel.

Stone Babies

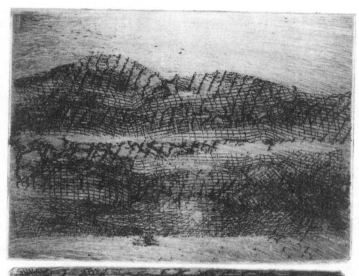

Burren

Stone Babies

'Ring a ring o' rosie.
a pocket full of posy,'
thorn-trees join branches,
to shed crimson berries
on a scatter of jagged stones
in this ringfort killeen.

Do stones keep badgers,
from this viridian Limbo?
Do skylarks sing lullabies
for small bones crushed
in unblessed Lisheenduff?
'A-tishoo. A-tishoo. We all fall down!'

No names,
for you are unbaptised,
born out of wedlock,
Will O' the Wisp babies!

Who covers dead babies
with daisy garlands, sings
'Ring a ring o' rosie' with you?
Who decorates small graves with quartz,
with granite fossils, limestone sea-lilies,
with metamorphosed corals?

Outcasts on this river edge
must you never cross over,
wait in darkness
with strangers?
Will water from Brigit's Holy Well
carry your bone-dust
to Bethlehem?
Or will you, Stone Babies,
sing 'Ring a ring o' rosie' forever?

Outside

Paper-white narcissi
ethereal on elegant stems
blossom from darkness.
Hyacinths in bowls,
pearl pink stars,
shoot exotic perfumes
from my window-sill.

Outside
below the garden,
Loch a tSaile,
a turquoise monster,
tumbles in the storm.

On Merchants' Road
crushed skulls of sleeping men
shoot crimson flowers.

Exiles

They remember mountain shapes,
bony masses hulking
from black-umber bogs.
They remember lilac shadows
moving across bulked rock.

Crushed between skyscrapers,
baked in underground carriages,
deafened in discos,
they remember sky-lakes
rough with tears.
They remember
peppery incense
of saffron furze.

Viridian thorns wrap
granite and limestone,
where haloes wild with colour
dissolve over Maam valley.

Fossiled and transformed
in the ring-round of life,
ancestors' clay,
their own clay calls to them.

Cave

I
My name is Eve.
I lie caged in rock.
Beside me remnants of ochre and fire.
Above me handprints, footprints
of dark ancestors.
I move my left hand,
my left arm.
Pain, searing pain,
screams through me.

II
Deep in the Cave
we see her.
On her side,
her flexioned skeleton
protected by stones.
Remnants of ochre and fire around her,
engravings and paintings
by dark ancestors.

We move her carefully,
place her in a glass cage.
Under lights we label her.
'Skeleton of young woman.
Race Protomediterranean.
Lived – 365 B.C. Burial Epipoleolitic.
Cause of Death – Fistulared mastoiditis
Height one point five three metres.'

III

She hears the throb of music.
Flesh returns to her bones.
Blood dances through her skin.
She hears an avalanche of sounds,
as her eyes open to this cathedral,
this extraordinary cave.

She sees musicians.

A tall man waves a wand
for 'Rite of Spring.'
Flower-sounds flow.
Pipes and horns,
threaded rods zange
across tendons stretched
on polished shapes.

Their music heals
her pain.

Two pale-skinned dancers
pirouette between stalactites, stalagmites.
One stands on tip-toe.
The other, bird-like, flies.

They do not speak.
They dance.

In the shadows,
beneath the cascade
other dancers move
in circles along the river
blessing the earth.

She moves her fingers.
She moves her toes.
Her ancestors' paintings
vibrate and dance with her.

She sees him in the orchestra.
Her love from a previous life.
She steps out from her cage.

She runs.
She flies.

They do not speak.
They dance.

For a Painter who Died Suddenly

High into the tower he climbed.
He carried Christ on his back.
For that last time he twisted upwards
towards the April night.

When he fell amongst cobalts
and ultramarines,
the Christ-bones offset
on his ivory shroud.

For three days he floated
in his sky-tomb,
as his blood congealed
on stretched boards.

We did not hear the keening of the Magdalens.
We did not hear the breaking of the bones.
We did not hear the bursting of the heart.
Nor see the lonely flutter of a scarecrow.

They closed him into a pale wooden box
and wedged him under a slabbed hill.

That stony cell is now
his cold cloister.
His painted shrouds
are hanging in the tower.

Haunted Space

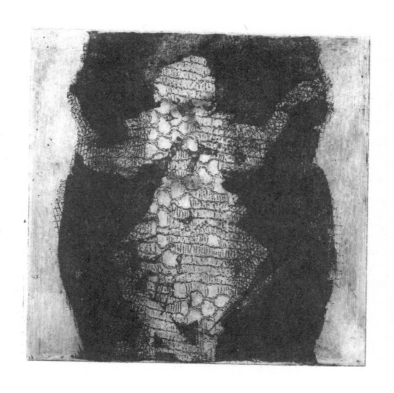

Petrushka

Haunted Space

By silent music of my blood,
womb-warmth of pressed earth
I know this space.
Haunted by a sense beyond my senses,
I love this amphora-theatre.
Here on the ocean edge, sky pulses
zig-zag through cerulean openings
to infinity of Cherubim, Seraphim
as polyphony of pigeons echoes
along ancient cloisters.

From darkness, I call,
'Benedicamus Domino',
to layered generations.
Keening of magdalens,
rock and roll of Elvis Presley
counterpoint Poor Clares'
vespers, complines, matins,
as I unwind crimson drapes
from baskets of cremated hearts.

Below deBurgo fireplaces
Brigit's Holy Well erupts
to resurrect Macha's pagan blessings.
River Corrib applauds Galvia's pregnant chant,
The Atlantic answers, 'Deo Gratias'.

Tomb

'I've lost him.
I've lost my lover.'
Eyes bruise-burning,
she stares at a blank canvas.

We her friends come
to sit on the earth
with her.
We listen to her low keening.

'This will be
my last,
my last painting.'
She rocks her body,
digs her fingers into the earth.
'This will be my shroud.'

We offer
chrome yellow,
burnt sienna, vermilion.

'Give me black. Night-black.
Opaque. Without life.
Without light'... She whispers.

'But you told us
to use a glowing dark.'

We watch.
She takes
a palette knife,
sharp and shining.
She mixes warm umber
with cool ultramarine.

We watch.
She covers
eyes, ears, mouth, nose,
her heart with glimmering dark.
We see her cover the pores of her skin,
as she rolls and curls
and wraps herself
in a luminous tomb.

Balla

Centuries ago
Saint Mochua
blessed this place
and named it
'Ball Aluinn'.

Today
a conservatory
empty of flowers
shelters that huge oak door.
On the terrace
tulips, flaming braziers,
have flown away
over a green cumulus
of beech and elm
towards Cnoc Spolgadain.

Our school orchestra
plays 'Ballet Music from Rosamunde',
viola, cello, violins,
double bass and grand piano.
As the ghost of Sir Robert Blosse Lynch
dances down the wide staircase,
falls and breaks its neck,
his wife pirouettes on tennis courts,
circles cedars in the pleasure grounds,
plucks garlands of strawberries
in the walled garden.

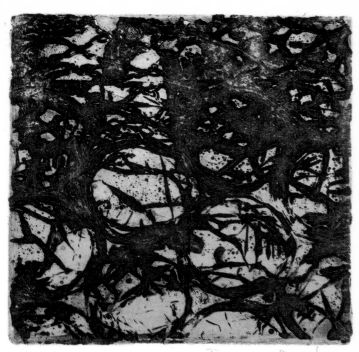

ap Night Beach Patricia Bushe

Sean Doras

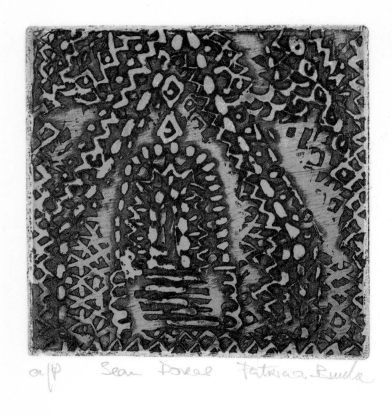

a/p Sean Doral Patricia Burke

Pucán

Sister Clara returns in rain
from the farm
with armfuls of gladioli and roses
to decorate the Altar.
In the Blue Assembly Hall
we paint flats, backdrops,
illusions for 'The Gondoliers'.
Rainbows glow through the conversatory.
Lilies, orchids, maidenhair ferns.

In black velvet edged with Clones Lace,
buckled patent shoes,
we praise Saint Louis,
'Dieu le Veult,'
and raise the fleur de lis
heavenwards as we walk
down the avenue towards Castlebar.

When an orchestra
plays Schubert,
I tune viola and violins again,
practise arpeggios, chromatic scales,
read Jane Eyre, Wuthering Heights,
Portrait of the Artist by torchlight
in Holy Angels' dormitory.
Ivory parchments, oriental perfumes
from the pleasure grounds
circle ancient cloisters.

Centuries ago
Saint Mochua
blessed this place
and named it
'Ball Aluinn.'

(Ball Aluinn is Gaelic for 'A beautiful place')

Aunt Clara

Last week I watched her being carried
towards a green gash
in the convent grounds in Middletown.

I see you again, Aunt Clara,
a white novice
with halo and wings taken
from our school theatre,
visit the death-cell
of a demented nun.
'I am the angel of good news, Sister!
Soon He'll call you to Paradise.'

Sister Thomas believed you
and died that night
with a smile on her face.

Did an angel visit
your deathbed, Aunt Clara?

Years ago you lifted me from tears
because the stones were sharp-toothed.
You carried me skywards
between high bogs of umber bilberries
and cello music from the swollen Shannon
past the bridge of Rooskey
to Ardbraccan.
Skywards again to Bornacoola
to this marble monument,

which stands
between the old monastery
and the Ogham Stone.
You traced his name
on white marble,
'Eugene Francis O'Beirne, your great uncle,
was first to cross the Rockies on foot.
His bones lie somewhere in Western Canada.
Buried without the Faith,
may he rest in peace.'

To-day I engrave your name,
'Clara O'Beirne',
on this monument
in Cloonmorris graveyard.

Clarenda

Were you carried by horses,
Clarenda, or did you walk,
carrying canvas and oils,
to stare at Rooskey Bridge
to mix colours on palette, to paint?
Did you walk, Clarenda,
along this avenue of wild cherry
edged with alizarin raspberries,
from your stone house by the Shannon?
Did you walk through Clooneen?

Did you wear his ring
as you mourned him who betrayed you?
Is this your life-message,
this painting of Rooskey Bridge?
Is this your message, Clarenda? –
Transfigure all pain
with colour and texture,
with tone and rhythm.

II
All that remains:
this painting and
your name, 'Clarenda O'Beirne,
died Novermber 28 1889, aged 54'.
Your life-story
carved on white marble

in Cloonmorris graveyard.
Your bone-dust mingles
with clay colours
between the old monastery
and Qenuven's Ogham Stone.

Were you carried by horses
on that road to Bornacoola,
their plumes of black mourning
against crimson heathers
a slow rhythm of death
intoning your requiem?
Were you carried by horses,
your life-envelope, Clarenda,
enclosed in bog oak?
Were you carried by horses?
Do you walk through Clooneen?

Robert O'Hara Burke

I, Robert O'Hara Burke,
descendant of the Red Earl of Ulster,
have won this race through Australia.

I am a conqueror!

Crimson crosses burned
on the hearts of my ancestors,
while they raised stone towers
above the flaming whins
and thorn-trees of Connaught.

In Melbourne
my beloved sings arias
to strangers.

At the Gulf of Carpentaria
vultures feed on my camels.
At Cooper's Creek,
deserted by Blake,
I watch Wills die of hunger.

Sandstorms aquatint my skull,
as my furred tongue
screams for the clear water
of St. Cleran's.

I bathe my memories in turloughs.
They disappear as I hallucinate.

Robert O'Hara Burke. Born in Dominick Street Galway City, he was raised a St. Cleran's, Loughrea. He and Wills were the first white men to cross Australia from south to north. On 1 July, 1861, he died of starvation.

Sanctuaries

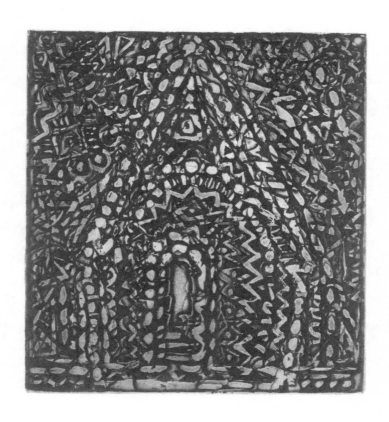

Sean Doras

Sanctuaries

A June sun offsets
sanctuary-window purples,
saffrons, vermilions
on crypt-grey limestone
in the Cathedral
of Tuaim Dha Ghualain.
Dramatic in crimson robes,
the mitred Archbishop
anoints row after row
of young foreheads.
Round scent of oil on skin.
Our shining whiteness
in stony distances.

Kneeling next to me,
Eileen O'Brien picks scarlet varnish
from her fingernails.
In answer to His Grace,
'Say the Apostles' Creed, my child!',
she stumbles and forgets
the drilled profession of Faith.
Veils flutter over satin dresses,
while the choir chants
'Veni, Creator Spiritus.'

But the secretary forgets
to register my name.

Shedding veil and dress
in the afternoon,
from the river bank
I dive into watery greenness.
I swim without fear
through an emerald tunnel.
With pilgrim heron and kingfisher
with pike and salmon,
I carve watery images.
Miracles of water anoint my body.

A strong and perfect Christian,
my fingers break through watercress.
Chant of the river throbs in my ears.
Taste of viridian, incense of
meadowsweet stretching my senses,
I glory in my limbs.
Joy undiminished,
my body is no prison
to contain my spirit.

I swim and swim
with minnows and dearogs,
with brown trout and otters
through cloisters of malachite.
Candelabra of wild iris light the banks.
Waterlilies float with me,
as I salute the clouds.

I write my name in water.

Draw Heaven

'Draw a picture for me, Daddy! Swallows home from Africa.
Draw salmon jumping up the river. Angels and Archangels.
Draw Christmas!'

Birds, fish, angels, stars and a frosted donkey float
on coloured space above the stable.

'Draw our old monastery across the road
and don't forget its magic lacy windows!'

He hangs all the magic in a wooden frame
above our book-case.

'Stop those mechanical men!
They're taking away our shining road!
Stop those yellow bull-dozers!
They're cutting up the monks!
Look, Teeth! Hair! Eyes! Rosary beads!
Hurry, draw the monks. – Draw Heaven!

But – Where's Heaven now, Daddy?'

Requiem at Christmas

I sing a requiem for you
at Christmas.
Tinsel and holly pierce my brain.
Not a star
but a twist
of black pain
is pinned
above each shining crib.

As snow, ethereal snow,
fades and turns grey,
so your face
loses its light.

You do not say goodbye
at Christmas.
You say,
'Thank you
for keeping watch.'

You die minutes
before I return
to sing for you.
Your eyes are fixed
in surprise
and I know
you can see again.

Transparent Quickstep

Ghosts are dancing cheek-to-cheek
 in Seapoint Ballroom.
Transparent close-knit quickstep waltz
 high-lit from a revolving sphere.
Rows of aching bacherlors return
 to double-doors and stairways.
Rows of girls sparkle
 on balconies, at floor-edges.

Dancers without shadows
 laugh, sing silently,
 while their coffins splinter
 in Galway, London, Boston, New York.

Enchanted
 we listen as
 the Bucharest Philharmonic
 tunes strings, percussion and woodwind.

We wait
 for Horia Andreescu,
 for Hidego Udagawa's violin.

Ghosts and Living
 silent
 as Horia raises his baton.

With Beethoven we mourn Egmont.
 Ghosts move to minuet rhythms
 as Udakawa celebrates Brahms.
Horia sculpts a lament for Minnehaha,
 Dvorak's Largo 'From the New World'.

 Horns, bassoons, oboes
 from Bucharest, from Tokyo
 transcend time-barriers.

Head bowed,
 Columbus prays
 under these folded hills
 upon these crumpled waters.

Transparent on the balcony,
 Peggy, Ambrose and Christopher
 watch hearts of the living dance,
 hearts of the spirit dance
 with the Bucharest Philharmonic
 in Seapoint Ballroom.

Slow Time

Floating
northwards
slowly.
Crossing
the equator.
Three hundred
million
years
ago
Galway
swims
in a tropical sea.

The cold comes.
The snow.
Great mountains of ice
move
slowly,
scrape flesh,
fill pockets
with treasures.
Slowly
sinking
bog moss enmeshed
limbs cross-hatched
in a freezing lake.

Northwards
floating.
Slowly,
slowly
turning
to
ice.

White Heat

1

In this oratory
> above snow-clouds of Carrara
I light a candle
> for millions of slave-ghosts,
who still move
> from sculpted caves
through thousands of years.

Obedient to Caesar,
> to lust for white marble,
iron-stained rock rejected,
> they cut and push
cubed ocean beds
> metamorphosed in white heat.

Along Via Aurelia Antigua
> broken-spirited towards Roma,
scumbles of marble dust
> layer their blood sweat,
mosquitos feast on their skin.
> Their heart-arteries implode.

Below this snow-line
> Dante pursues Beatrice
Michelangelo comes to release his angels.

Under that carved staircase
 at Teatro Tredici di Firenze,
forgotten magdalens
 eat translucent larda,
bleach stained linens,
 open our laundry-basket hearts.

Apennine ice melts
 on these ravaged mountains,
where machines carve
 monstrous whitenesses
for Japanese palaces.

On this polished altar
 my candle burns
and dies.

Miracle

'It'll grow like new potatoes.
Next week you'll have twenty shillings,'
neighbours' children persuade me.
Under lilies more glorious than Solomon,
a five-year-old believer,
I plant my shining shilling-for-sweets.

'But He was sold too!'
Parents comfort
my clay splattered heart.

'Faith can move mountains.'
I hide my school knitting
in our antique cheese-dish.
'Angel Guardian, please finish
the heel of my sock.'

Eclipsed now by vampire stars,
I dig up my heart-shilling.
Out of that old darkness
I stand at the ocean-edge
and fling-spin my betrayals
across knitted wave-tips
into the miracle of light.

Glossary of Irish terms, names and place-names

Aillwee = Aillwee Cave in the Burren, Country Clare.

Ballinagall = Ancient name for Galway.

Brigit's Holy Well = St. Brigit, Abbess of Kildare and Patroness of poets, had the gift of healing. Holy Wells are named in her honour.

Burren = Karst landscape of North County Clare.

Cnoc Spolgadáin = A hill in County Mayo.

Corcomroe = Preserved remains of a Cistercian monastery in the Burren.

Dearog = Small Fish.

Galvia = Galvia or Gaillimh, daughter of Breasail, was drowned in River Corrib. Tradition holds that Galway was named after her.

Gentians = Small ultramarine flowers of Alpine origin found in the Burren.

Gleninsheen = Site of a portal tomb in the Burren. A gorget of sheet gold, the Gleninsheen Collar, which was found there is now in the National Museum.

Gleoteog = Sailing boat used in Galway Bay.

Killeen = Remains of small cell.

Lisheenduff = Burial place of unbaptized infants in County Galway.

Maam = Valley in Connemara.

Macha = Pagan Goddess.

Ogham Stone = Early Irish linear script inscribed on pillar-stone.

Poulnabrone = Portal Tomb in the Burren.

Pucan = Sailing boat used in Galway Bay.

Qenuven = Pagan goddess.

Ringfort = Remains of circular fortification.

Turloughs = Small lakes, which appear and disappear in limestone landscapes.

Whins = Yellow furze.

Will o'the Wisp = A fairy light, which dances across Irish bogs at night.